Marc Chagall

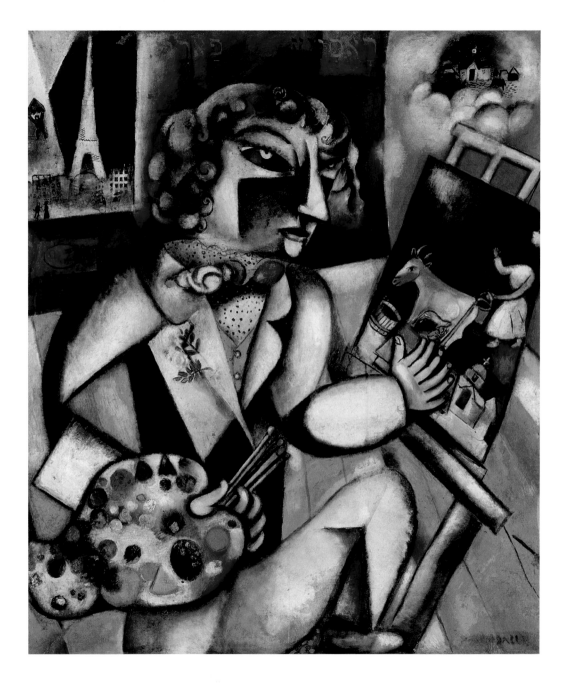

Marc Chagall

Monica Bohm-Duchen

Tate Introductions
Tate Publishing

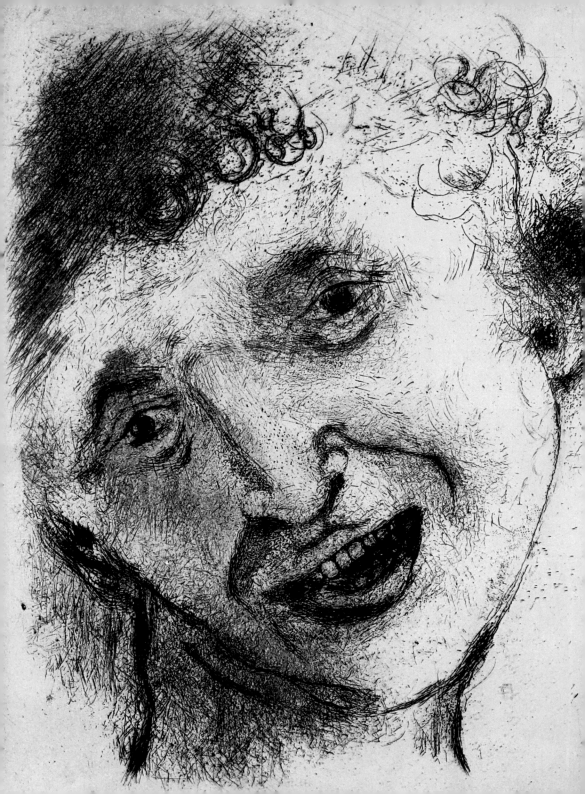

Inauspicious Beginnings?

In *My Life*, the wonderfully evocative and utterly unreliable autobiography that Marc Chagall wrote while still in his thirties,[1] he claimed that 'a word as fantastic, as literary, as otherworldly as the word "artist" – well, I might have heard of it, but it had never been uttered by anyone in our town'.[2] Vitebsk, the Belarusian town of some 65,000 inhabitants (of whom over half were Jewish) where Moyshe Shagal was born on 6 July 1887, the eldest of eight children, to poor, pious, Yiddish-speaking parents (fig.2), may not have been the ideal place to harbour artistic ambitions; but, as we will see, this is by no means the whole story.

In the deeply observant Hasidic Jewish environment in which he grew up, it is true that the visual arts played a minimal part and were indeed regarded with considerable suspicion – a legacy of the taboo on idolatry contained in the biblical Second Commandment.[3] One of Chagall's many uncles was, the artist tells us, 'afraid to offer me his hand. They say I am a painter. Suppose I was to sketch him? God forbids it. A sin.'[4] Yet it is possible that the more instinctive, even sensual nature of Hasidic Judaism meant that image-making was regarded with rather less abhorrence than was the case in other, more traditionally orthodox Jewish communities.[5] Despite the fact that he ceased to be a practising Jew in early adulthood, Chagall's lifelong anti-intellectualism and distrust of conventional logic, his conviction that the material and the spiritual worlds are closely linked, even his intense empathy with the animal world, can all be seen – in part at least – as a legacy of his cultural and religious heritage.[6]

Chagall's mother, Feiga-Ita, soon realised that her son possessed unusual gifts and managed with the help of a fifty rouble bribe to open the doors of the local Russian-speaking elementary school (from which Jews were officially barred) to him.[7] In the face of his father Sachar's blank incomprehension, she would continue to provide

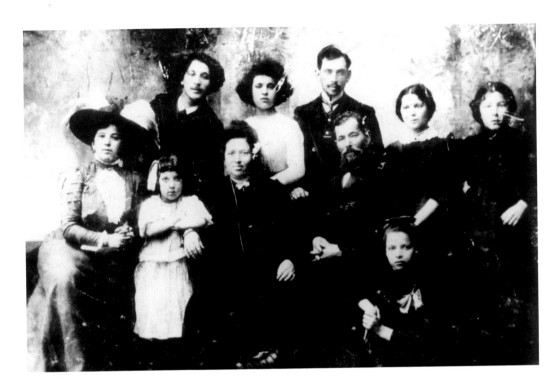

her eldest son with both moral and practical support. It was at this school that he watched with wonder as a classmate copied a magazine illustration; following suit, a whole new world opened up to him.

There were other Jews in Vitebsk, however, who were more affluent and secularised (though still religiously observant) and led very different kinds of lives from Chagall's uneducated, working-class parents. One of these was the painter Yehuda Pen, a member of a group of young Jews who, thanks in part to the trail-blazing example of sculptor Mark Antokolsky,[8] were able to study at the Imperial Academy of Arts in St Petersburg in the 1880s, and who in 1897 had opened an art school in Vitebsk to which Chagall was admitted at the age of nineteen. Although in later life the artist would play down the extent of Pen's influence on his formative years, there is little doubt that the latter's achievements, and in particular his specialisation in conventional but sensitive scenes of Russian-Jewish life (fig.3), set the young man an important example.

2. Chagall's family in the early 1900s. Chagall is at the back on the far left and his parents in the centre of the group, with his uncle Neuch behind his father. His sisters, from left to right: Aniuta, Marussia, Zina, Rosa, Lisa, Mania. Archives Marc et Ida Chagall, Paris

Only a few of Chagall's very early works have survived. Most of these seem to have been somewhat hesitant, technically awkward renderings of the modest wooden structures that formed his immediate physical environment, self-portraits and portraits of those close to him (fig.14). By 1908, by which time he had left Vitebsk to study art in St Petersburg, his work reveals a far greater assurance and originality. Notable here is *The Dead Man* c.1908 (fig.15), a child-like yet haunting image based partly on his real-life experience of witnessing a distraught woman running through the streets calling on others to come and save her husband, and partly on the Yiddish expression for a deserted street, literally a dead street. Similarly, the 'fiddler on the roof' and the boot suspended in the air allude to the fact that in times of danger it was not uncommon for people to escape onto the rooftops, and to another (not very complimentary) expression about playing the violin 'like a cobbler'. This semi-conscious amalgam of composite childhood memories and a witty visualisation of linguistic idioms would become the hallmark of much of Chagall's mature work.

Widening Horizons: The Move to St Petersburg

In the bigger and far more Westernised metropolis of St Petersburg, where he arrived in the winter of 1906–7, Chagall's cultural horizons expanded dramatically. The transition was not, however, an easy one, the problem of finding a congenial teacher being compounded by the practical difficulties facing any Jew from the Pale of Settlement wishing to reside in the capital.[9] A disappointing stint as a student at the Imperial Society for the Protection of the Arts was followed by an equally unsatisfactory one at a private school run by the genre painter Savely Zeidenberg. Only when Chagall discovered the Zvantseva School, which included among its teachers Léon Bakst (born Lev Rosenberg), best known for his designs for Sergei Diaghilev's Ballets Russes, did he feel more at ease. Although Bakst's own work, smacking of an exotic hothouse (fig.4) and the World of Art society to which he belonged,[10] exerted little direct influence on Chagall, the fact that this was 'the only school animated by a breath of Europe' proved crucial.[11] Also crucial, of course, was his encounter with the masterpieces of Western art housed in the Hermitage Museum. As *Self-Portrait with Brushes* 1909 (fig.16)

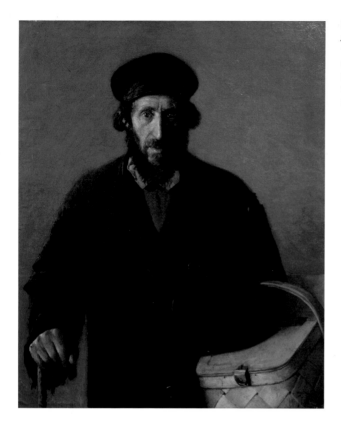

3. Yehuda Pen
An Old Man with a Basket
1892
Oil on canvas
70 × 59.5
Museum of Regional and
Local History, Vitebsk

testifies, it was to the work of the great seventeenth-century Dutch
painter Rembrandt that he responded most enthusiastically. A profound
affection and admiration for Rembrandt's work would remain with
him throughout his life.

The journal *Apollon*, with which Bakst was associated, and the
exhibitions it organised of work by artists such as Gauguin, Bonnard,
Derain and Matisse, opened Chagall's eyes to the achievements of the
French avant-garde. It was at the premises of this magazine, moreover,
that in the spring of 1910 Chagall exhibited his work in public for the
first time, in a group show by students at the Zvantseva School. Once
Paris and its freedoms beckoned, it is hardly surprising that his sights
were set on getting there. Not even his burgeoning romance with
the beautiful Berta (later Bella) Rosenfeld (fig.5), daughter of one of
the wealthiest Jewish families in Vitebsk, whom he met on one of
his frequent return visits to his home town, deflected him from his

4. Léon Bakst
Set design for the ballet
Schéhérazade 1910
Watercolour, gouache
and gold on paper
54.5 × 76
Les Arts Décoratifs, Paris

ambitions.Thus it was that, armed with a modest stipend from liberal lawyer and politician Maxim Vinaver, one of the first Jewish members of the *Duma* (Russian parliament), the twenty-three-year-old Chagall set out by train for the French capital in May 1911.

Paris: City of Light

If St Petersburg had been a bewildering, even daunting experience, how much more so was the French capital: 'Only the great distance that separates Paris from my native town prevented me from going back home immediately ... [but] it was the Louvre that put an end to all this wavering.'[12] Important lessons were also learnt by visiting the large annual public exhibitions, the Salon des Indépendants and the Salon d'Automne, and by peering into the galleries of avant-garde dealers such as Paul Durand-Ruel, Alexandre Bernheim, Daniel-Henri Kahnweiler and Ambroise Vollard. Chagall was firmly convinced that Russian art was 'condemned by fate to follow in the wake of the West',[13] and that Paris – which came to represent 'light, colour, freedom, the sun, the joy of living', what he eloquently called *lumière-liberté*[14] – was where he had to stay. Yet, paradoxically, it was his exotic 'otherness', in personal and artistic terms alike, that made him so distinctive a figure in the undisputed capital of the art world.

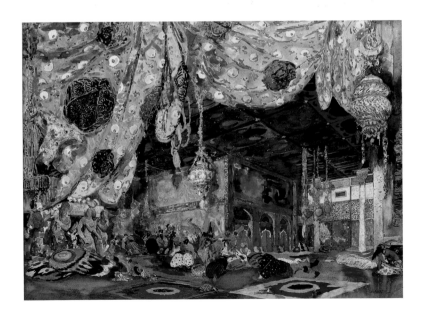

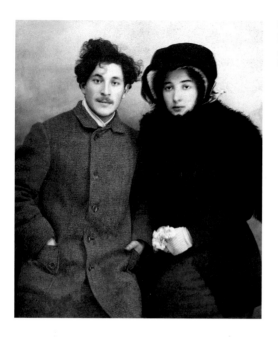

5. Chagall and Bella
Rosenberg, c.1910
Archives Marc et Ida
Chagall, Paris

Enrolled in classes at the privately run Académies de la Grande Chaumière and de la Palette (although he attended these only sporadically), one of Chagall's responses to the new freedoms offered by Paris was to produce a number of images of defiantly sexual female nudes (fig.17), a subject that barely features in his earlier oeuvre, or indeed in Russian art generally. In their heightened colours and fragmented forms, these represent a somewhat unresolved response to the latest aesthetic developments, namely fauvism and cubism, to which he would have been exposed at the Académie de la Palette, run by the minor cubist painter Henri Le Fauconnier and his Russian-born wife. As *The Studio* 1910–11 (fig.18) testifies, Van Gogh was another significant influence at this time.

However, the paintings that soon attracted the attention of open-minded and discerning critics, many of them poets including Guillaume Apollinaire and Blaise Cendrars, were of a very different kind. Although borrowing stylistic devices from cubism and orphic cubism in particular (the creation of Robert Delaunay, one of Chagall's very few painter friends, and his Russian-Jewish artist wife Sonia), the subject matter of utterly original canvases such as *Birth* 1911, *I and the Village* 1911 (fig.19), *To Russia, Asses and Others* 1911–12

(fig.20), *The Cattle Dealer* 1912 (fig.21) and *The Violinist* 1912–13 (fig.22) derives from memories of his Russian-Jewish youth and childhood. Even images not explicitly dealing with that experience, for example *Half Past Three (The Poet)* 1911 and *Paris Through the Window* 1913 (fig.23), are imbued with a fantastical humour far removed from the more earthbound concerns of a typical cubist composition.

The image that most vividly sums up the fertile complexity of Chagall's allegiances at this period in his life is *Self-Portrait with Seven Fingers* 1912–13 (see p.2). On the one hand, there is Paris, represented by the Eiffel Tower, seen through the window on the left of the composition; on the other, Vitebsk, represented – significantly – not by a synagogue but a church, glimpsed among the clouds, as if in a dream, on the right. Although the rendering of Chagall's own body pays stylistic tribute to cubism, the painting shown on the easel, immediately recognisable as *To Russia, Asses and Others*, makes it clear which of the two geographical locations dominated Chagall's imagination. The additional fact that Paris and Russia are identified as such in Yiddish may hint at a certain tension between his Russian and his Jewish roots; the mysterious extra fingers on his left hand can be explained by a Yiddish saying, whereby to do things with seven fingers means doing something really well and with all one's heart.

The uneasy relationship with the 'host culture' of his native Russia finds more explicit expression in *Calvary* 1912 (fig.24), the first major work by Chagall ever to be sold and the first to reveal his lifelong preoccupation with the figure of Christ. That a very personal and quite un-Christian interest in Christian imagery dates back to his early days in Russia is borne out by such slyly subversive works as *The Family* or *Maternity* 1909 (also known as *Circumcision*) and *The Holy Family* 1910. In its inconsistent perspective and non-naturalistic handling of space, *Calvary* recalls not only Parisian cubism but also the great tradition of Russian icons, whose iconography Chagall utterly subverts. The work may well have been painted as a response to the Beilis Affair in Russia, when a Jew of that name was arrested in 1911 on the age-old, trumped-up charge of having murdered a Christian child for ritual purposes; only in 1913 was Beilis finally acquitted. Chagall's distaste for a religion that still permitted this sort of outrage may well have fuelled his brush on this occasion and further intensified his ambivalence towards Christian culture.

In a similar vein, *Pregnant Woman* or *Maternity* 1913 (fig.25), with its peasant woman pointing to the child inside her belly, contains a sardonic reference to a well-known type of Madonna and Child to be found in the Russian icon tradition, in which the Christ Child is emblazoned in a medallion on the Madonna's chest (fig.6). In contrast, works such as *The Pinch of Snuff* 1912 represent a more straightforward, albeit consciously primitivising reworking of Jewish genre themes treated by Chagall's former teacher Yehuda Pen among others.

As was publicly acknowledged at the time by the coining of the (not always complimentary) term *École juive*, a disproportionate number of the many foreign artists who congregated in Montparnasse before and after the First World War – and in the ramshackle studio complex of La Ruche in particular – were of Jewish origin, most of them hailing from the Yiddish-speaking communities of Russia and Eastern Europe. For them, Paris offered not only artistic freedom, but religious and social freedom too. The majority, however, chose to turn their backs on ethnically or religiously explicit iconography. Certainly, of all the major talents – among them, Jacques (born Chaim Jacob) Lipchitz, Chaim Soutine and Jules Pascin (born Julius Mordecai Pincas) – Chagall was the only one not to do so.

Return to Russia

In 1914, Chagall was offered his first one-man exhibition, not in Paris, but in Berlin, at the editorial offices of *Der Sturm*, an avant-garde publication produced by Herwarth Walden (born Georg Levin), to whom he had been introduced by Apollinaire. The exhibition, although modest and informal, was critically well received and marked the beginning of the artist's international reputation. Chagall was in too much of a hurry to continue eastwards to Vitebsk to reclaim the affections of his girlfriend Bella to linger long in Berlin, however. In June 1914, he boarded a train for Vitebsk, planning to marry Bella, then whisk her back, first to Berlin, and on to Paris. Little did he know that world events were about to overtake him and that he would be forced to remain in Russia for eight whole years.

Caught in Vitebsk by the outbreak of the First World War, Chagall re-immersed himself in Russian-Jewish life, which he depicted in a far more accessible and (relatively) naturalistic manner than

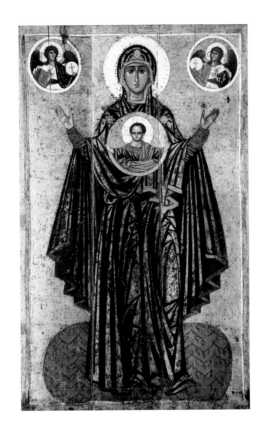

6. *The Great Panagia of Yaroslavl*
13th century
Tempera on panel
194 × 120
The State Tretyakov Gallery, Moscow

in the work of his first Parisian period. Tender portraits of his family (fig.26) and of Bella (fig.27) coexist with poignant images of archetypal members of the Jewish community (fig.28) and of soldiers and their loved ones (fig.29). Only a few images, such as a number of questioning self-portraits (fig.30) and *Feast Day* 1914 (fig.31), betray a hint of ambivalence at that re-immersion. Meanwhile, a stint of official war service as a not very efficient clerk in the Office of War Economy in Petrograd (since 1914, the name for St Petersburg) left him with enough time not only to draw but also to start penning his autobiography. Marriage to Bella in 1915 resulted in a series of lyrical yet sensuous celebrations of their love, such as *Birthday* and *The Poet Reclining* (fig.32). May 1916 saw the birth of their first and only child, Ida, an event commemorated in charming images such as *The Infant's Bath* and *Strawberries* or *Bella and Ida at the Table* (fig.33). In reality, Chagall did not take to fatherhood naturally or easily.

He continued, however, to celebrate his union with Bella in works such as *The Promenade* (fig.34), *Double-Portrait with Wine Glass* (both part of a particularly joyous, gravity-defying series of 1917–18) and *The Wedding* 1918.

In the meantime Chagall was forging links with other artists, writers and intellectuals, such as Nathan Altman, El Lissitzky, Issachar Ber Ryback and Boris Aronson, intent on exploring and exploiting Russian-Jewish folk art in their quest for an authentic modern Jewish art. It was at this time too that he produced illustrations for Isaac Leib Peretz's humorous short story *The Magician* (1916) and two poems by Der Nister ('The Hidden One', pseudonym of Pinkhes Kahanovich), thus paving the way for a more widespread interest in creating a secular Yiddish art-book tradition. Chagall's successful sojourn in the French capital, combined with the obvious relevance of his earlier work, lent him a certain glamour in the eyes of his contemporaries, who saw him as a paradigmatic figure. Altman was a particularly active member of this group, helping – along with Chagall's old mentors, Vinaver, Pen and others – to found the Society for the Encouragement of Jewish Art in Petrograd in late 1915 or early 1916. Chagall himself participated in the first exhibition of the Society; in early 1917, a substantial number of his works were included in a controversial show entitled *Paintings and Sculptures by Jewish Artists*, staged by the Society but held in Moscow. In the pages of the Yiddish journal *Shtrom*, Chagall would defend the project, expressing his pride in belonging to 'this little Jewish people who gave birth to Christ and Christianity. When there was a need for something else [they] came up with Marx and Socialism. So why couldn't [the Jewish people] also give the world a specifically Jewish art?'[15]

It was probably this Society that in 1916–17 gave Chagall his first public commission, to produce a series of paintings to decorate a Jewish secondary school adjoining the main synagogue in Petrograd. Preparatory studies – *Visit to the Grandparents*, *The Feast of Tabernacles* (inspired by a page from the Mantua Haggadah, the Passover text, of 1560), *Purim* and *Baby Carriage Indoors* – reveal that for this project he abandoned the blend of realism and cubism in which many of his paintings of this period had been rendered, in favour of a more populist faux-naïf folk style indebted to the tradition of Jewish *lubki* (popular woodblock prints) and painted

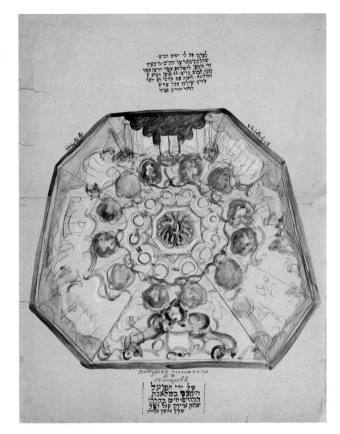

7. Issachar Ber Ryback
The Ceiling of the Mohilev Synagogue 1916
Watercolour, gouache and india ink over black chalk
645 × 480
The Israel Museum, Jerusalem

wooden synagogue interiors. The outbreak of the Russian Revolution in 1917, however, meant that the large-scale paintings for which these studies were intended were never executed. In 1916 the Jewish Historical and Ethnographical Society made it financially possible for Lissitzky and Ryback to undertake an expedition to record the vividly decorated interiors of the wooden synagogues along the River Dnieper, whose child-like exuberance and anthropomorphised animal forms would exercise a profound influence on them. The synagogue of Mohilev (fig.7) would have held a particular attraction for Chagall. This was one of the very few interiors bearing an inscription identifying its creator, 'By the artisan who is engaged in sacred craft, Haim the son of Isaac Segal of Sluzk' – whom Chagall (whose family name had originally been Segal) would claim as his fictive ancestor.

Chagall's reaction to the February and October Revolutions of 1917 was more enthusiastic than his previously apolitical stance would have led anyone – including himself – to expect. However, as a Jew and as an artist he could not fail to be excited at the prospects opening up before him. For the Jews of Russia, the new order would lead to full citizenship for the first time: the liquidation of the infamous Pale of Settlement, and an end to the quota on Jewish students in universities and to the internal passport system that had once landed Chagall in prison. For orthodox Jews (like Chagall's father), the Revolution offered the hope that they would at last be able to practise their religion without fear of prejudice and persecution. Ironically, for already secularised Jews like Chagall, the Revolution promised to sweep away not only Tsarist tyranny, but also the tyranny of Jewish orthodoxy.

Chagall soon found himself intimately involved with the radical restructuring of the art world that followed hard on the heels of political revolution. Supported by Anatoly Lunacharsky, head of the newly established People's Commissariat of Enlightenment (NARKOMPROS), whom Chagall had first encountered in La Ruche, he was duly appointed Commissar for Art in the region of Vitebsk. Unsurprisingly, this left him little time to paint, although atypical works such as *War on Palaces* c.1918 (fig.35) reveal that for a while at least he was prepared to put his art entirely at the service of propaganda. Nevertheless, the designs he produced for banners to mark the first anniversary of the Revolution met with a mixed reaction: 'My multi-coloured animals swung all over the town, swollen with revolution. The workers marched up singing the International. When I saw them smile, I was sure they understood me. The leaders, the Communists seemed less gratified. Why is the cow green and why is the horse flying through the sky, why? What's the connection with Marx and Lenin?'[16] His difficulties were compounded by the arrival at the Vitebsk Public Art School, probably at the instigation of Lissitzky, previously Chagall's 'most ardent disciple',[17] of the charismatic Kasimir Malevich, pioneering advocate of a pared-down geometric abstraction known as suprematism, which he deemed the only appropriate art form for a brand new utopian society. Lissitzky promptly switched allegiances and matters deteriorated as Chagall's grip on authority loosened. That Chagall was not immune to

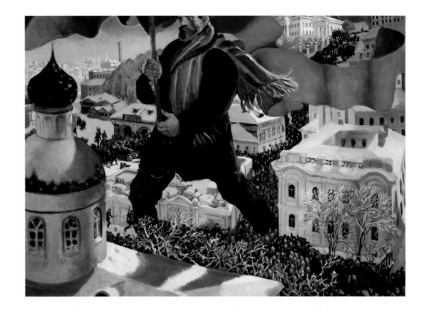

Malevich's influence, however, is borne out by works such as
Profile at Window 1918 (fig.36) and *Composition with Goat* c.1920,
which pay lip-service to geometric structures while slyly subverting
them with witty figurative elements.

By mid-1920, Chagall's position at the Vitebsk Art School was
untenable; Bella's warning that it would all end in tears had proven
well-founded. Moving to Moscow, Chagall turned to the only
institution that still seemed to want him: the burgeoning Jewish
Theatre. Viewed in a more positive light, the move from Vitebsk to
Moscow enabled him to pick up the threads of his pre-Revolutionary
interest in Jewish culture. Indeed, it was only in the theatre, which
became a meeting ground for all of the arts, to some extent insulated
from the outside world, that the pre-1917 fervour to create a
specifically Jewish art form would be sustained until the mid-1920s,
by which point it had faded, or been suppressed, in other areas of
cultural activity. Thus it was that in 1920 Chagall began to work for the
State Yiddish Chamber Theatre (Gosudarstvenni Evreiskii Kamernyi
Teatr, or GOSEKT). While his crowning achievement here was
undoubtedly the set of murals that he created for the Theatre itself
(fig.37) – which came, as a result, to be known as 'Chagall's Box' – he
also designed the sets and costumes for a substantial number of its

productions (fig.38), all of which exercised a conspicuous influence on other Russian-Jewish artists. Many of the motifs to be found in these magnificent Yiddish Theatre murals are monumental reworkings of those originally created in his first Parisian period: *Music* 1920 (fig.39), for example, is clearly a close relation of *The Violinist* 1912–13 (fig.22). They would also provide a rich fount of dramatic, witty and life-affirming imagery – animals, acrobats, actors, musicians and the like – upon which Chagall would draw from memory for the rest of his long life (*Music*, for instance, would resurface in 1923–4 as *The Green Violinist*).

By 1921, however, Chagall had fallen out with the Theatre's Director, Aleksandr Granovsky. By then, with socialist realism already beginning to assert itself as the preferred style of the Communist regime (fig.8), it was also clear that the future did not bode well for experimental art, figurative and abstract alike. Civil war, moreover, was still raging and physical hardship prevailed. The last project on which Chagall worked in Russia was a set of stylistically hybrid, visually inventive illustrations for a series of poems by David Hofshteyn entitled *Mourning* (1922), a lament for the Jewish victims of recent Russian history.

Return to the City of Light

In 1922 Chagall and his small family left Russia for good, arriving in Berlin (via Kaunas in Lithuania) in May. Although he managed to bring with him a consignment of artworks, many – including, for obvious reasons, his monumental Yiddish Theatre murals – had to be left behind. (Only with the fall of Communism after 1989 was the West able both to access Chagall's very earliest productions, and to fully appreciate the quality and quantity of the work he produced between 1914 and 1922.) Berlin was teeming with Russians who were profoundly disillusioned with the turn events, both political and artistic, had taken in their native country. It was here that Chagall first tried his hand at printmaking, under the tutelage of graphic artists Joseph Budko and Hermann Struck, prompted by the suggestion made by German-Jewish publisher and dealer Paul Cassirer that he illustrate his autobiography, *My Life* (fig.9).

In 1923 Chagall at last fulfilled his dream of returning to Paris. On his arrival, however, he discovered that virtually all the work

he had created there between 1911 and 1914 had disappeared or been sold off. (The same was true of the work he had left in Berlin in 1914.) To assuage a recurring sense of loss, Chagall proceeded to re-create many of these canvases from memory (for example, fig.40), which had the result of creating some confusion in the art market when the original canvases resurfaced. For the most part, though, the 1920s were a tranquil decade for the artist, in which he sought to assimilate himself into French cultural traditions by painting lovers, acrobats, landscapes (fig.41), flowers and animals, often with a fantastical element that endeared him to the surrealists (fig.43), although he firmly resisted their invitation to join their ranks. This decade also demonstrated his mastery of the graphic medium, in the form of a series of witty and richly textured book illustrations commissioned by art dealer Ambroise Vollard, notably for *Dead Souls* (1923–7) by Nikolai Gogol, and Jean de la Fontaine's *Fables* (1927–30) (fig.42).

By the early 1930s, world events – above all, the rise of Fascism and the accession of Adolf Hitler to power – compelled him to return to his Jewish roots, resulting in brooding masterpieces such as *Solitude* 1933 and *White Crucifixion* 1938 (figs.44, 46). It was in this

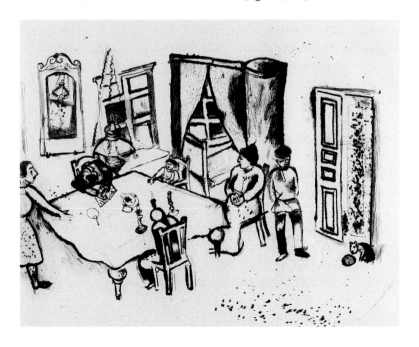

decade too that, prompted by a commission from Vollard, Chagall travelled to Palestine for the first time, in preparation for a series of etchings (preceded by gouaches) on Old Testament themes (fig.45).[18] Yet, when the Second World War broke out in 1939 and the Nazis occupied France a few months later, he was slow to understand the grave personal dangers this posed to him and his family: after all, he had been granted French citizenship in 1937, and Gordes, the Provençal village to which they had retreated, seemed safe enough. Only in 1941, at the official invitation of The Museum of Modern Art in New York and at the urging of its emissary Varian Fry, did he finally agree to seek refuge in America.[19] Leaving France in May, he arrived (via Spain and Portugal) in New York on 23 June 1941, just a day after the German invasion of Russia.

Exile in America

Although Chagall spoke no English and made no attempt to assimilate into American culture, his time in America, first in Manhattan and then in upstate New York, was not unproductive. Haunted by an awareness of the likely fate of his family in Vitebsk and of the rest of European Jewry, he became almost obsessed with the image of the suffering Jesus as the original Jewish martyr and embodiment of modern Jewish suffering – even, as in works such *The Descent from the Cross* 1941, going so far as to identify himself with Christ or, as in *Crucifixion* 1944 (fig.48), replacing Jesus on the cross with the figure of a bearded Eastern European Jew. (His poems of this period also testify to his profound feelings of anxiety and guilt.) In 1942 an invitation from the American Ballet Theatre to design a production of Pyotr Tchaikovsky's *Aleko*, a project with a strong Russian element, led to a trip to Mexico and came as a welcome distraction. The wonderfully life-affirming and visually striking costumes and stage backdrops that resulted certainly belie the context of their making (fig.47).

Tragedy nearer to home struck in September 1944, when Bella died from an infection for which no penicillin was available. For virtually the only time in his long life, Chagall lost the will to create, albeit only briefly. When he began painting again, an elegiac sense of loss was all-pervasive, as in *Around Her* (fig.49) and *The Soul of the Town*, both 1945. In spite of this, it was not long before he found solace with another woman, British (non-Jewish) Virginia Haggard McNeil,

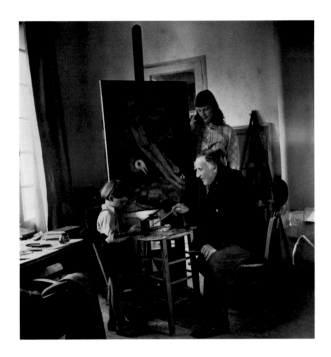

twenty-eight years his junior; although they never married, she bore him a son, David, in 1946 (fig.10). When a redhead appears in his paintings of this period, this is clearly a tribute to his newfound love. Another commission, to create designs for Igor Stravinsky's *The Firebird* (1945), and work on illustrations to *The Arabian Nights* (1946) also helped distract him from his grief.

Grand Old Man of Modern Art

In April 1946, Chagall was given the accolade of a major retrospective exhibition at The Museum of Modern Art in New York, which eighteen months later travelled in condensed form to the Musée national d'art moderne in Paris. France was obviously ready to receive him again and after several preliminary visits he decided to return for good in 1948. Works of the early 1950s, such as *The Madonna of Notre Dame* and *The Banks of the Seine* (both 1953), testify to his renewed links with the city to which, although blighted by its wartime history, he owed so much. That Vitebsk and Bella were rarely far from his mind, however, is borne out by their inclusion in works such as *Champ de Mars* 1954–5 (fig.51).

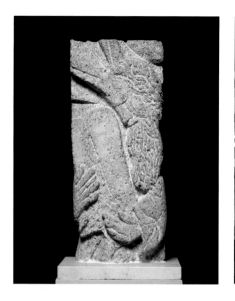

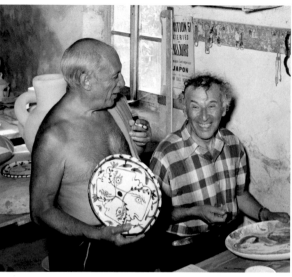

At first he lived with Virginia and David in Orgeval, outside Paris. By the time she left him in 1952 – he would marry Russian-Jewish Valentina (Vava) Brodsky (fig.13) just a few months later– Chagall was living in the south of France: initially, in 1949, in St-Jean-Cap-Ferrat; then in Vence, from 1950 to 1966; and thereafter until his death, in St Paul-de-Vence. Exhibitions and commissions increased in number, notable among them his work in stained glass for some of the great medieval cathedrals of Europe (fig.52), for the synagogue at the Haddasah Medical Centre in Jerusalem and for the United Nations building in New York; his ceiling for the Paris Opéra (fig.53); and his murals for the Metropolitan Opera House in New York. In 1955 he embarked on a series of large canvases on Old Testament themes, later housed in the purpose-built Museum of the Biblical Message Marc Chagall (now known as the Marc Chagall Museum) in Nice (fig.54). At the same time, he was experimenting with a welter of new media: sculpture, mosaics, tapestry and ceramics (figs.11, 12, 55). At a time of life when most people are choosing to slow down, his prodigious energy showed no sign of abating. Although much of the work he produced from the 1960s onwards has been accused (with some justification) of a certain over-facility, sentimentality and superficiality (this is particularly true of his lithographs, made for a mass market), his best late work achieves an impressive

11. Marc Chagall
Moses 1952–4
Rognes stone
53 × 22
Musée national Marc Chagall, Nice

12. Picasso and Chagall, Madoura ceramics studio, Vallauris, early 1950s

monumentality, more than a little tinged with darkness (fig.56). *War* 1964–6 (fig.57) is a vivid embodiment of his unresolved – and unresolvable – grief at the loss of the Russian-Jewish world of his childhood; in *The Fall of Icarus* 1975 (fig.58) the doomed figure from Greek mythology falls not into the sea, but onto a Jewish *shtetl*. Works such as *The Big Circus* 1968 and *Large Grey Circus* 1975 (fig.59) testify to his lifelong preoccupation with the circus as a rich metaphor for the vagaries of human existence (see also fig.50).

Marc Chagall died on 18 March 1985, at the grand old age of ninety-seven, working on drawings, gouaches, watercolours and lithographs almost until the end (fig.60). As virtually the only surviving member of an heroic generation that also included Picasso, Matisse and Braque, he had become an almost emblematic figure, with too much emphasis perhaps laid on his later, less complex, but more readily accessible work. Chagall was in fact a complicated and multifaceted individual, whose warm, witty and life-affirming art achieves the rare distinction of combining comedy and tragedy to strike emotional, spiritual and aesthetic chords of universal relevance.

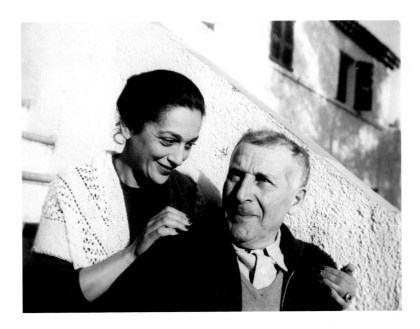

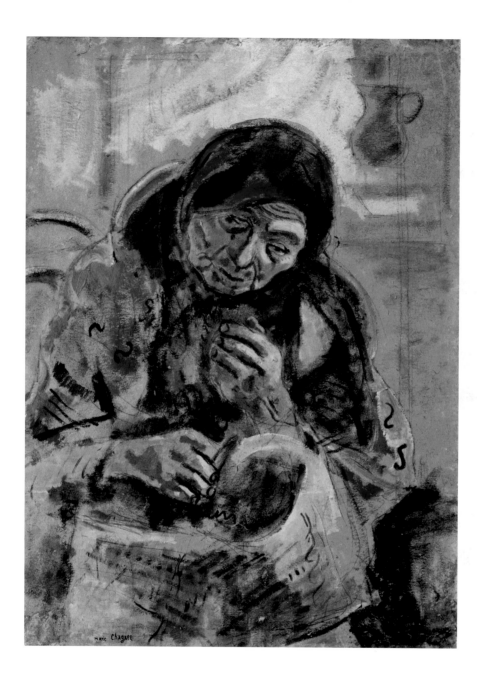

14
Woman with Basket
1906–7
Gouache, oil and charcoal
on cardboard
67.5 × 49.3
The State Tretyakov
Gallery, Moscow

15
The Dead Man 1908–9
Oil on canvas
68.2 × 86
Musée national d'art
moderne, Centre Georges
Pompidou, Paris

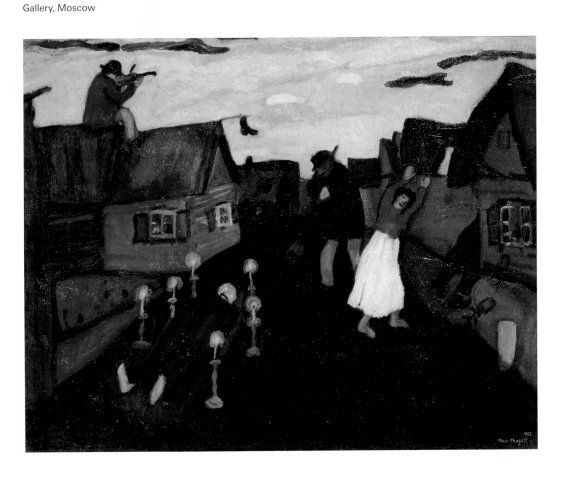

16
Self-Portrait with Brushes
1909
Oil on canvas
57 × 48
Kunstsammlung
Nordrhein Westfalen,
Düsseldorf

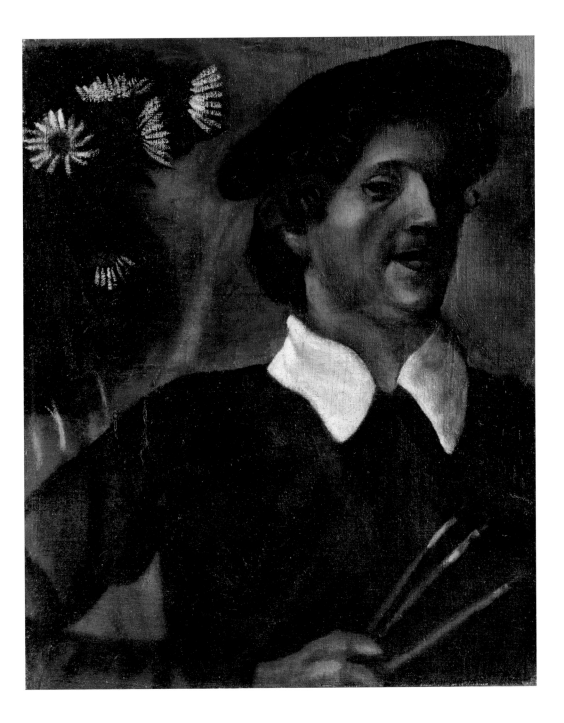

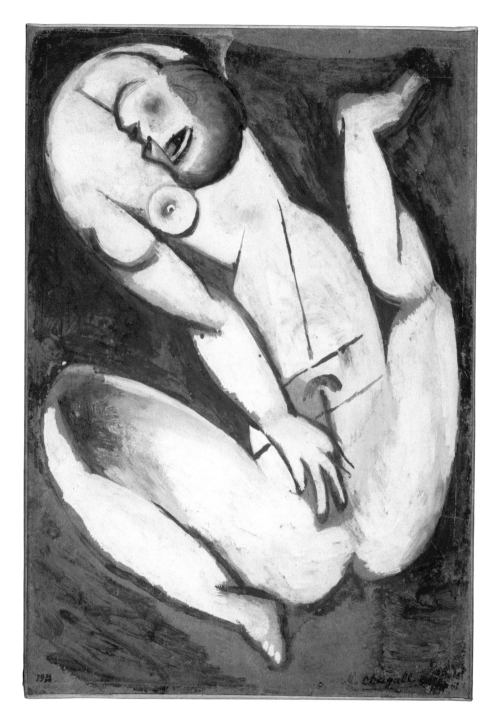

17
Nude in Movement 1913
Gouache on brown paper,
mounted on canvas
34.7 × 23.9
Musée national d'art
moderne, Centre Georges
Pompidou, Paris

18
The Studio 1910–11
Oil on canvas
60 × 73
Musée national d'art
moderne, Centre Georges
Pompidou, Paris

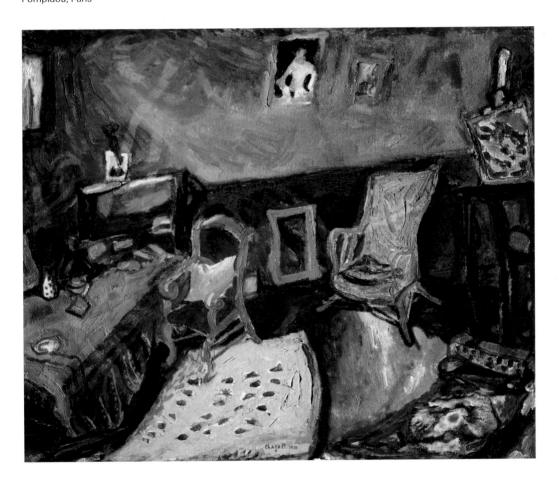

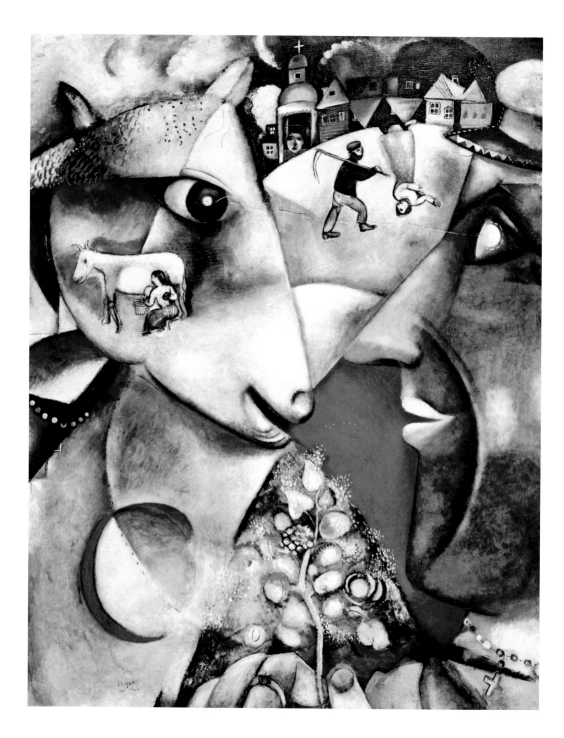

19
I and the Village 1911
Oil on canvas
192.1 × 151.4
The Museum of Modern
Art, New York

20
*To Russia, Asses and
Others* 1911–12
Oil on canvas
157 × 122
Musée national d'art
moderne, Centre Georges
Pompidou, Paris

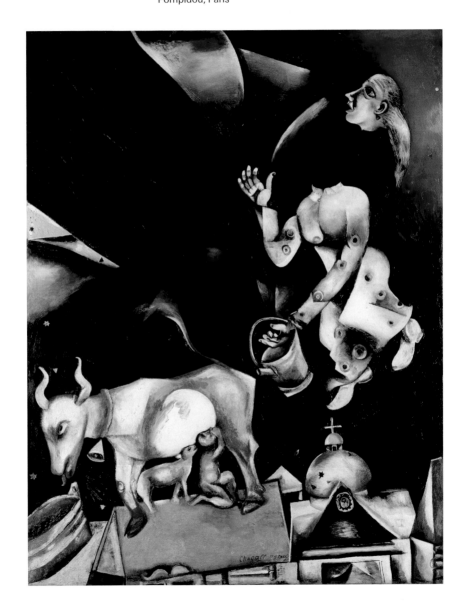

21
The Cattle Dealer 1912
Oil on canvas
97 × 200.5
Kunstmuseum, Basel

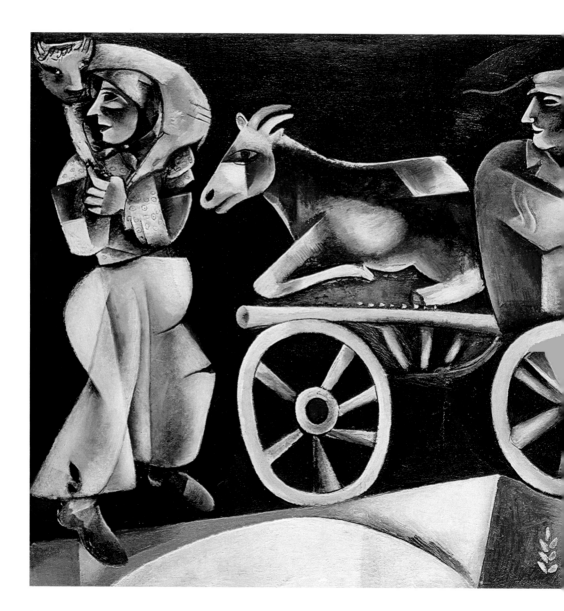

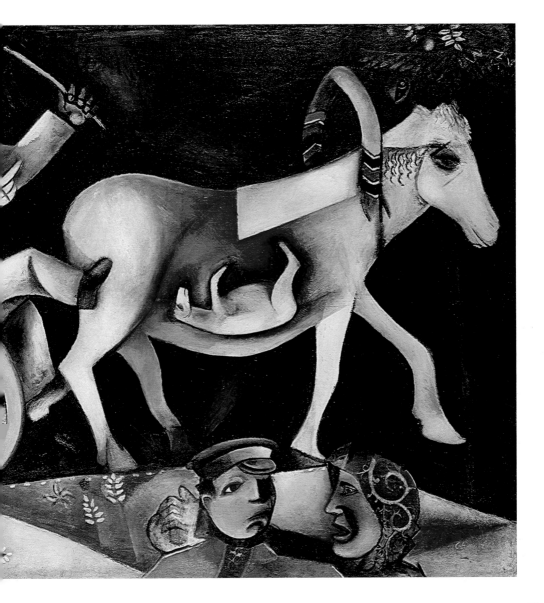

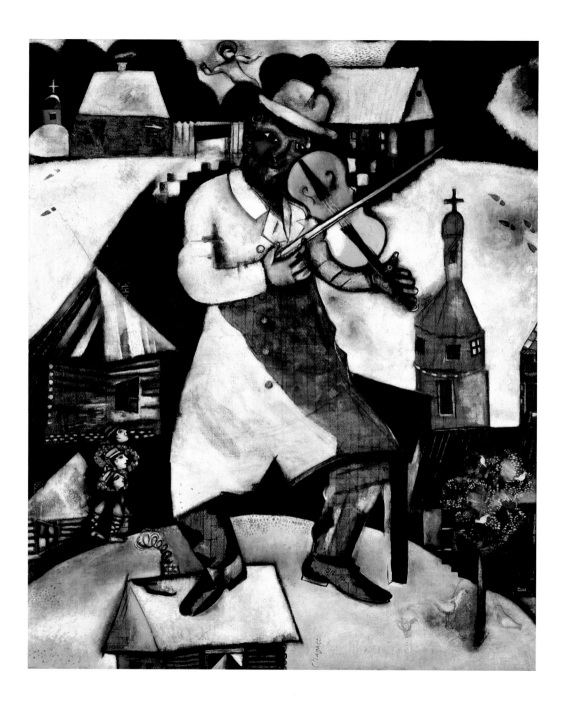

22
The Violinist 1912–13
Oil on canvas
188 × 158
Collection Stedelijk
Museum, Amsterdam

23
Paris Through the Window
1913
Oil on canvas
135.9 × 141.6
Solomon R. Guggenheim
Museum, New York

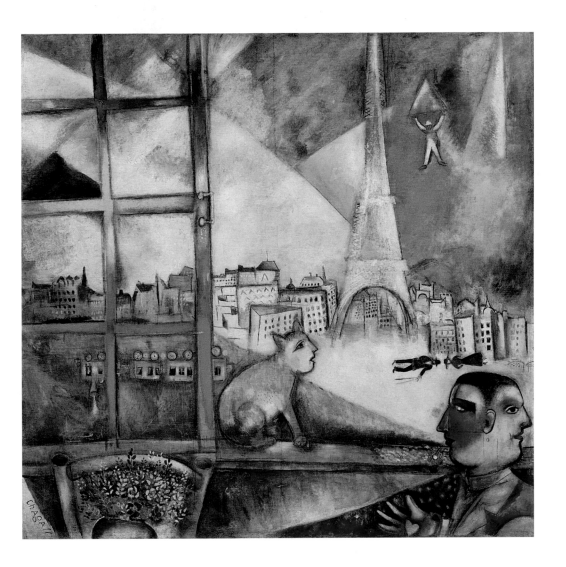

24
Calvary 1912
Oil on canvas
174.6 × 192.4
The Museum of Modern
Art, New York

25
Pregnant Woman or
Maternity 1913
Oil on canvas
194 × 114.9
Collection Stedelijk
Museum, Amsterdam

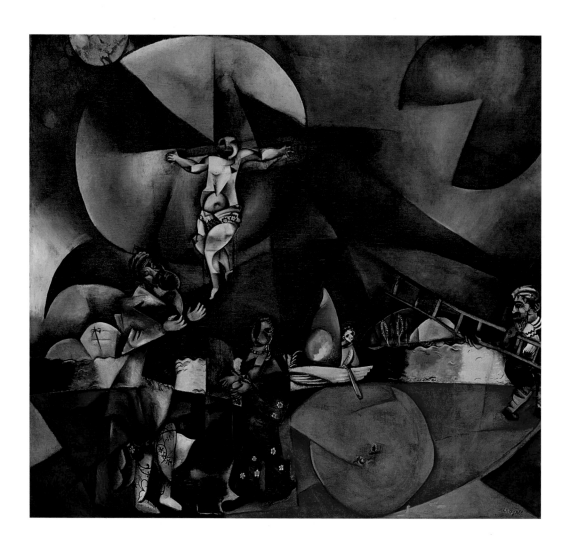

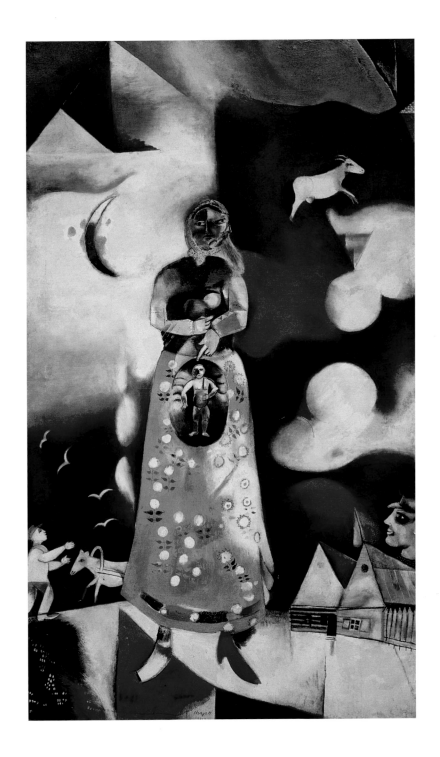

26
David 1914
Oil on paper, mounted
on cardboard
50 × 37.5
Private collection

27
Lovers in Blue 1914
Tempera on paper,
mounted on cardboard
49 × 44.3
Private collection

40

28
Jew in Red 1915
Oil on cardboard
100 × 80.5
The State Russian
Museum, St Petersburg

29
Departure for War 1914
Indian ink and pencil on
paper
21.7 × 17.1
Private collection

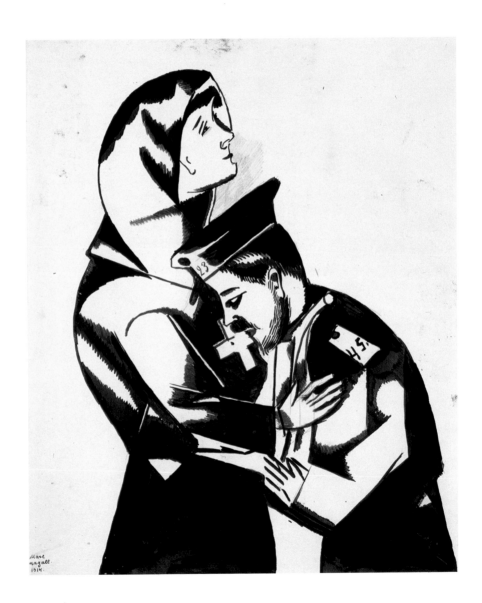

30
Self-Portrait 1914
Oil on cardboard, mounted
on canvas
50.5 × 38
Kunstmuseum Basel

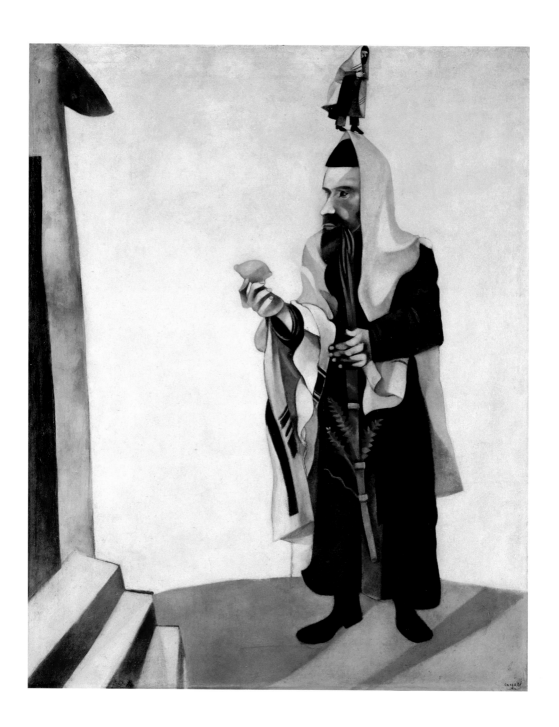

31
Feast Day 1914
Oil on canvas mounted
on cardboard
100.5 × 81.3 × 2.3
Kunstsammlung
Nordrhein-Westfalen,
Düsseldorf

32
The Poet Reclining 1915
Oil on cardboard
77.2 × 77.5
Tate

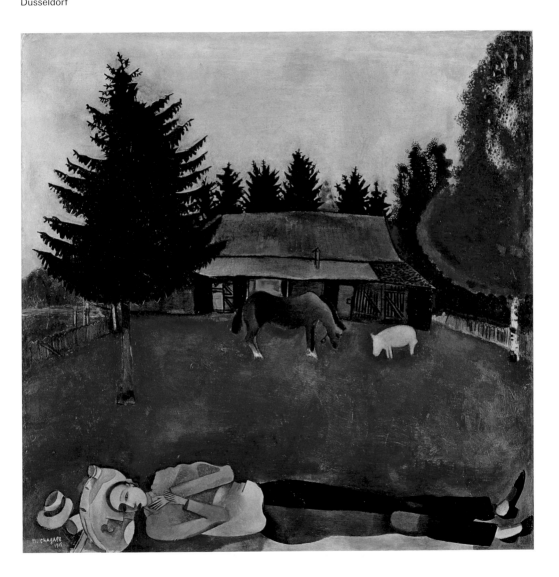

33
Strawberries or *Bella and Ida at the Table* 1916
Oil on canvas, mounted on cardboard
45.5 × 59.5
Private collection

34
The Promenade 1917–18
Oil on cardboard
170 × 163.5
The State Russian Museum, St Petersburg

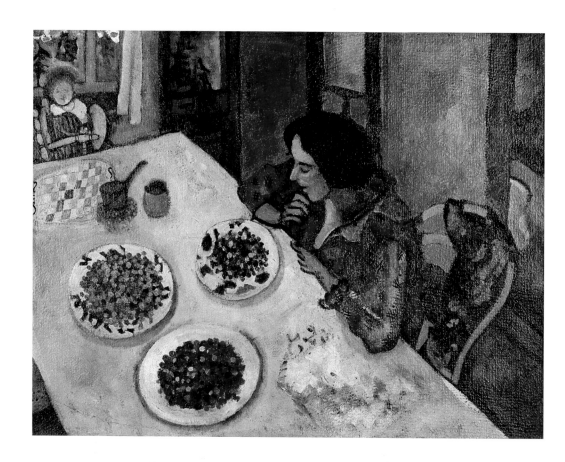

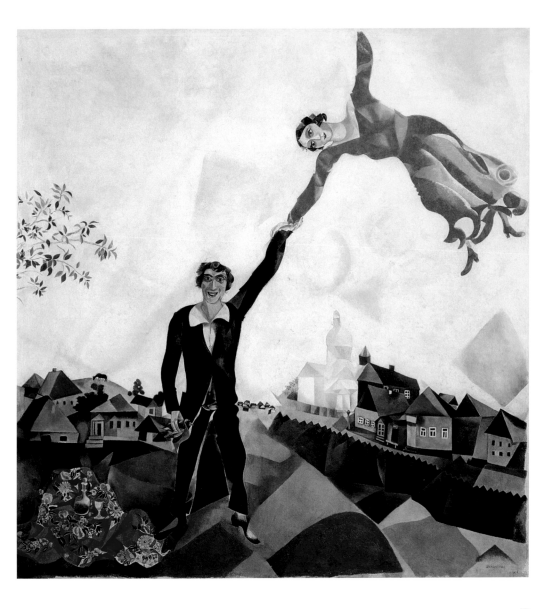

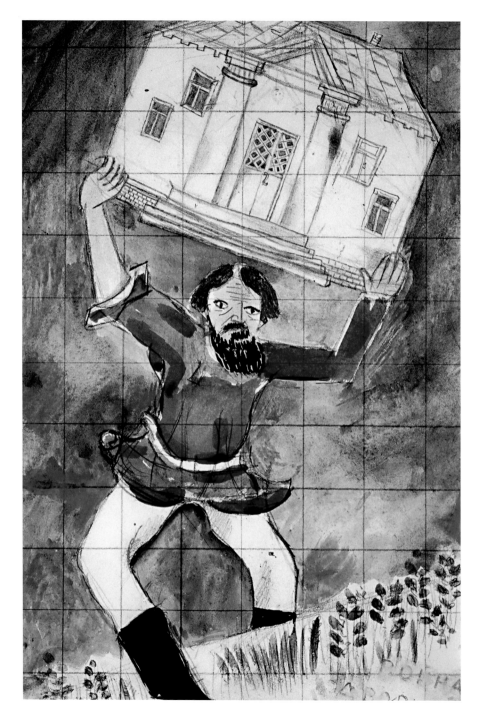

35
War on Palaces c.1918
Watercolour and pencil on
paper
33.7 × 23.2
The State Tretyakov
Gallery, Moscow

36
Profile at Window 1918
Gouache and ink on brown
cardboard
22.2 × 17
Musée national d'art
moderne, Centre Georges
Pompidou, Paris

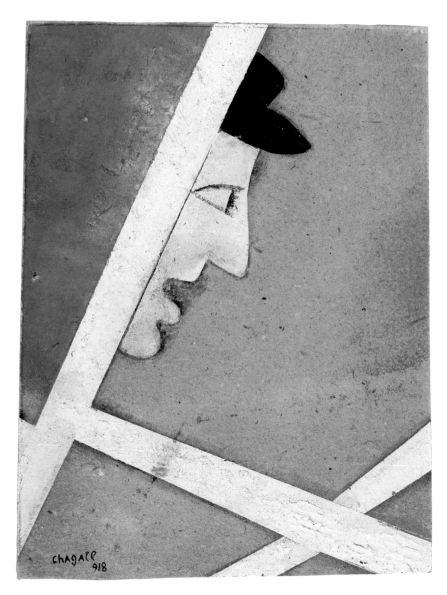

37
*Introduction to The Yiddish
Theatre* 1920
Tempera, gouache and
opaque white on canvas
284 × 787
The State Tretyakov
Gallery, Moscow

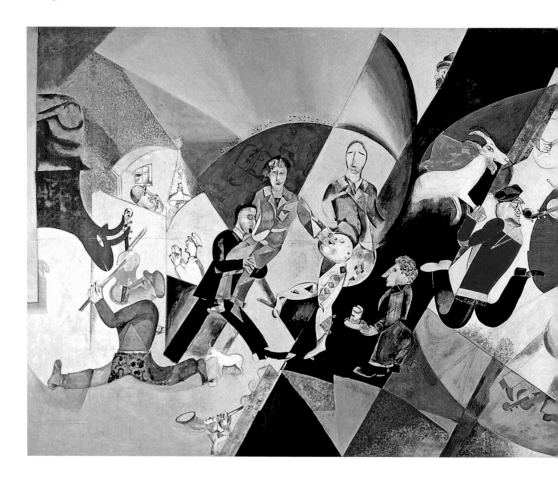

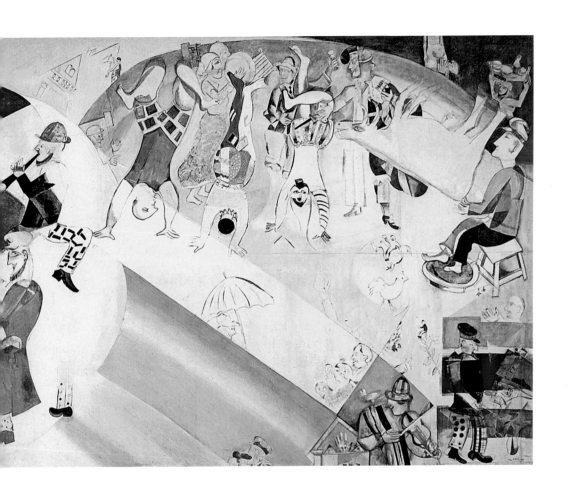

38
Sketch for Sholem
Aleichem's *Mazel Tov*
1920 (dated 1919)
Oil and pencil on paper
47.5 × 63.5
Private collection

39
Music 1920
Tempera and gouache on
canvas
213 × 104
The State Tretyakov
Gallery, Moscow

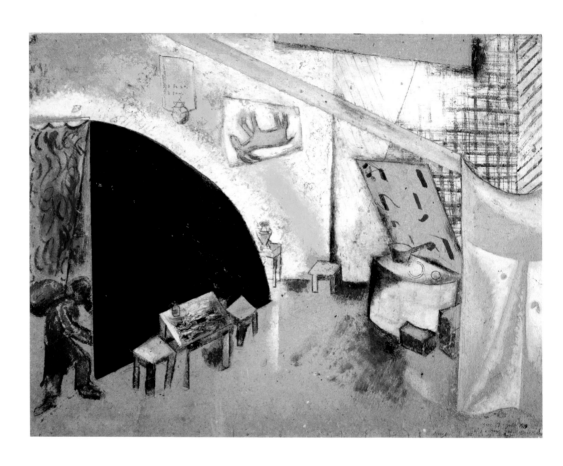

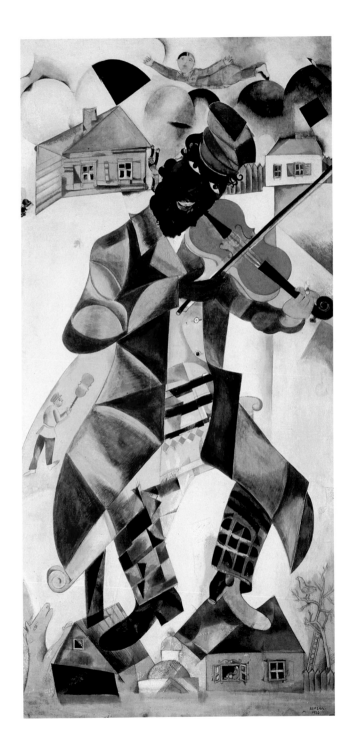

40
Over Vitebsk 1922
Oil on canvas
73 × 91
Kunsthaus Zürich

41
*Window on the Isle of
Bréhat* 1924
Oil on canvas
100.5 × 73.5
Kunsthaus Zürich

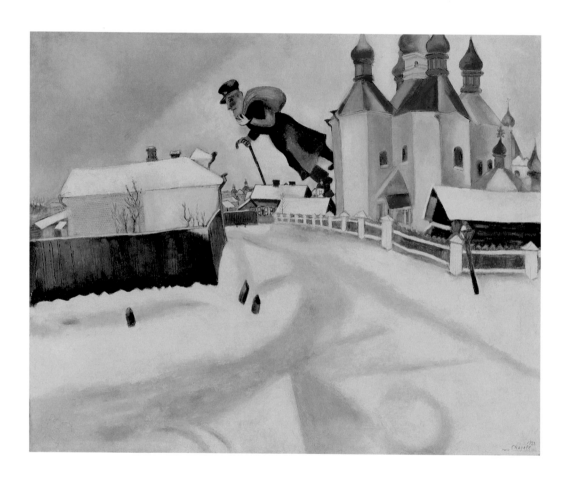

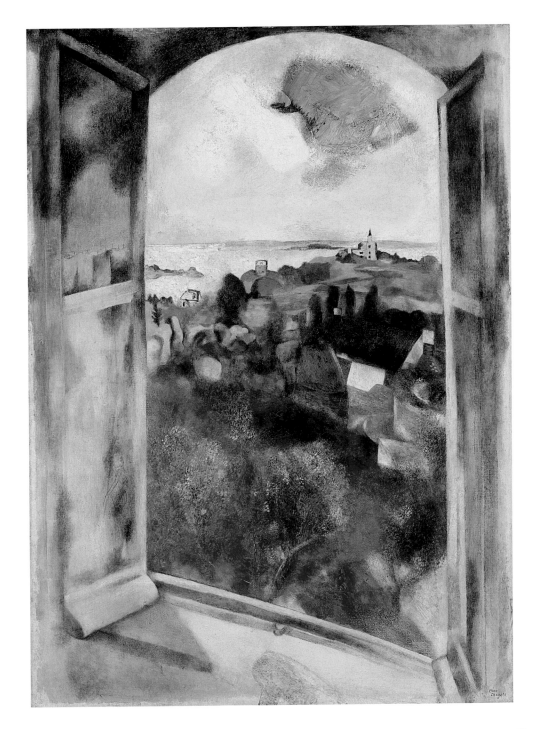

42
*The Peacock Who
Complained to Juno*,
from *Fables* by Jean de la
Fontaine 1927–30/1952
Etching
The Israel Museum,
Jerusalem

43
The Cockerel 1929
Oil on canvas
81 × 65.5
Thyssen-Bornemisza
Collection, Madrid

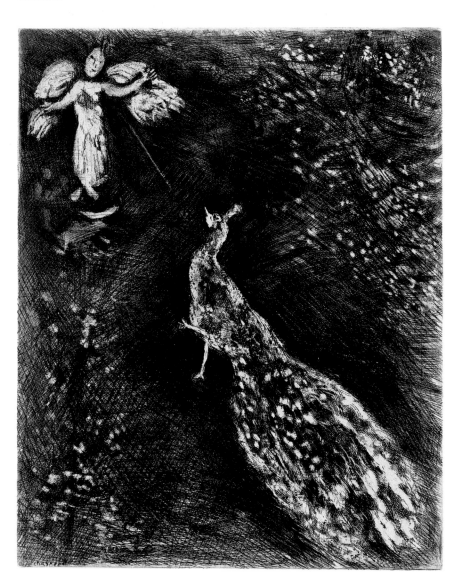

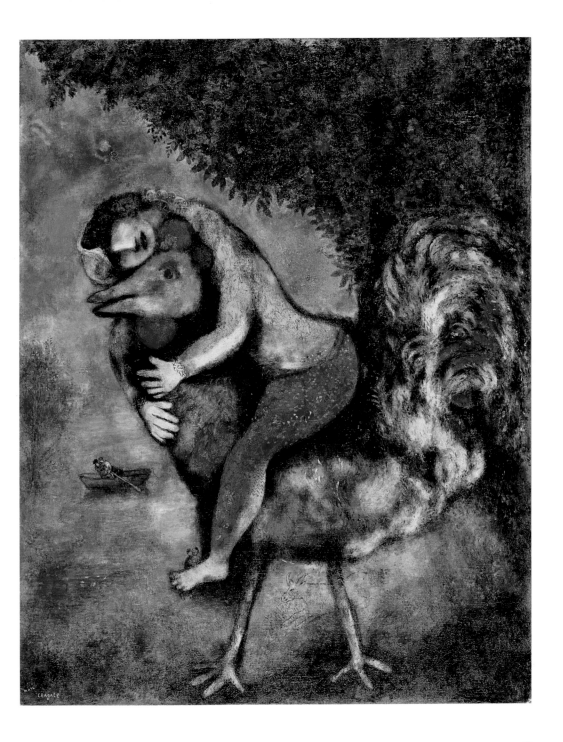

44
Solitude 1933
Oil on canvas
102 × 169
Collection of the Tel Aviv
Museum of Art

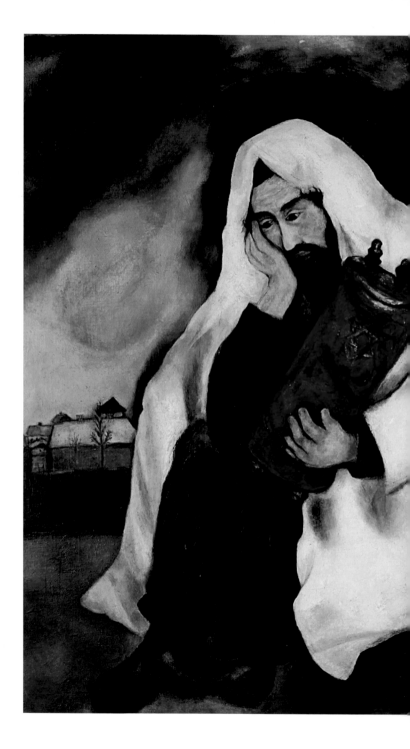

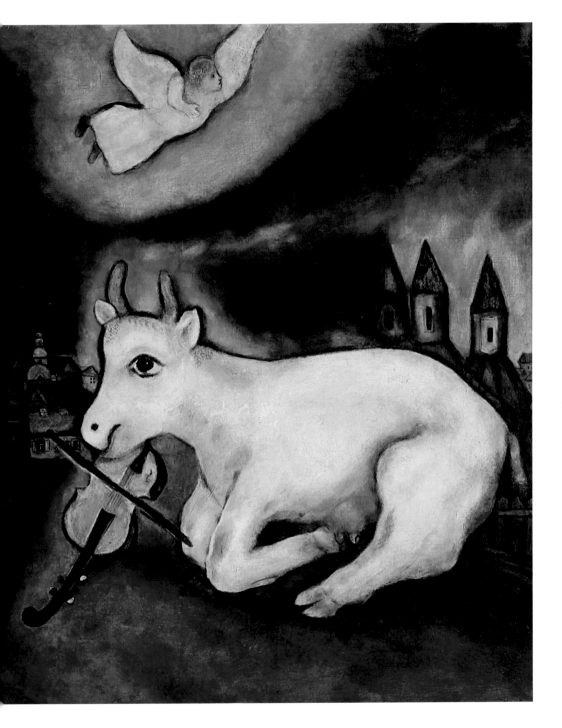

45
*Abraham and the Three
Angels* 1931
Oil and gouache on paper
62.5 × 49
Musée national Marc
Chagall, Nice

46
White Crucifixion 1938
Oil on canvas
155 × 139.5
Art Institute of Chicago

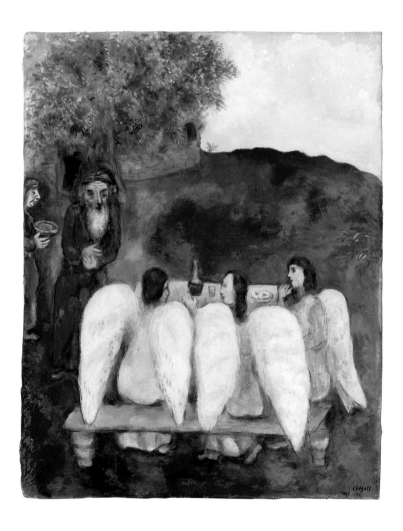

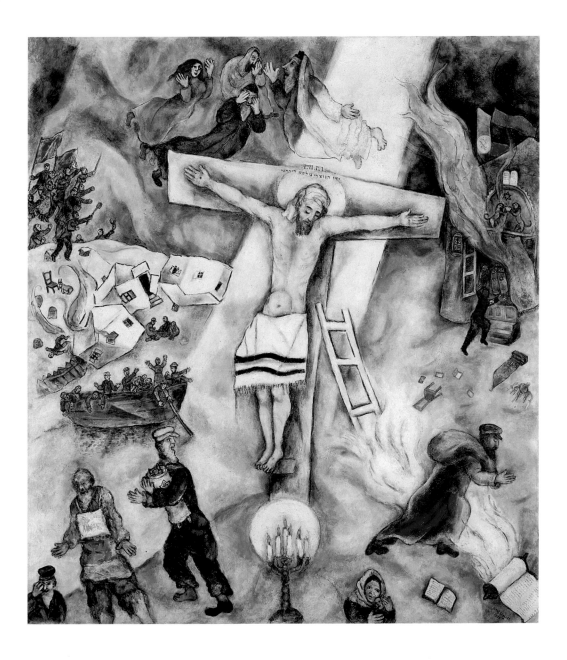

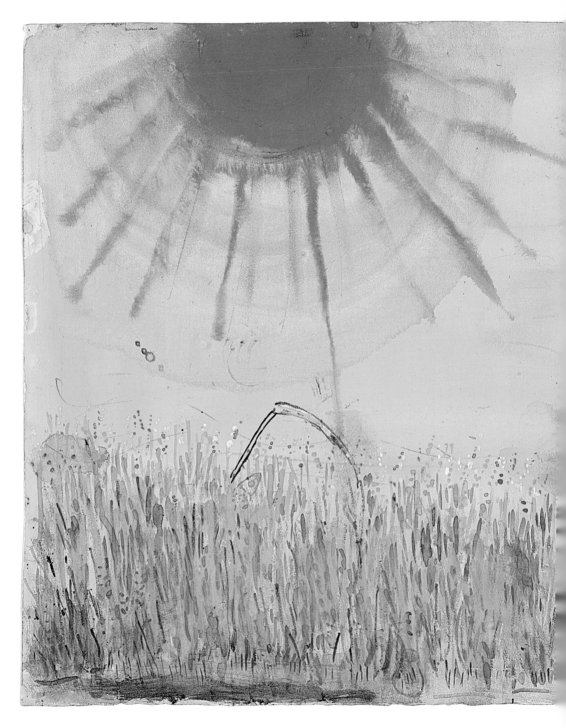

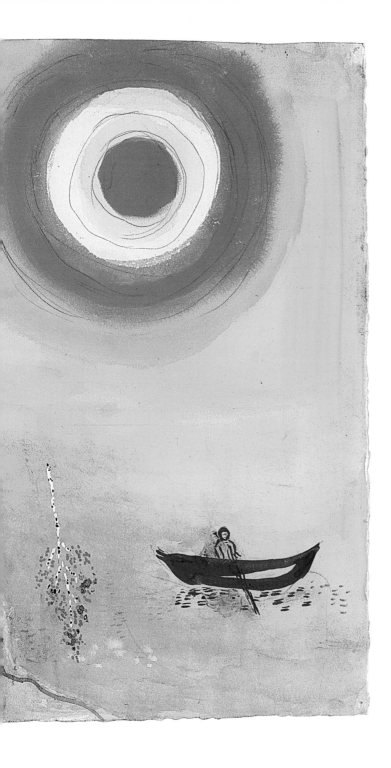

47
A Wheatfield on a Summer's Afternoon, decor for *Aleko* (Scene III) 1942
Gouache watercolour and pencil on paper
38.7 × 57.2
The Museum of Modern Art, New York

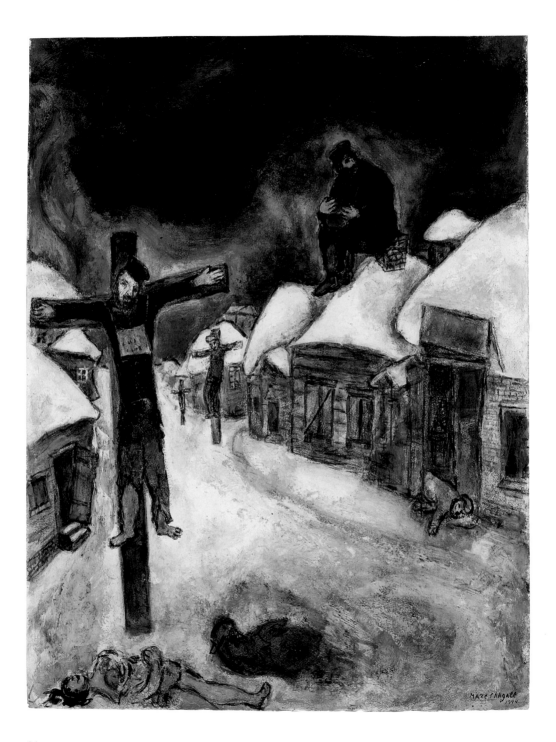

48
Crucifixion 1944
Pencil, gouache and
watercolour on paper
65 × 50
Israel Museum, Jerusalam

49
Around Her 1945
Oil on canvas
130.9 × 109.7
Musée national d'art
moderne, Centre Georges
Pompidou, Paris

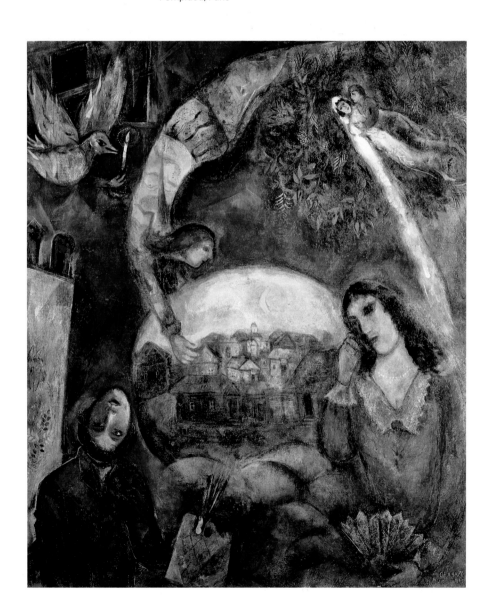

50
The Blue Circus 1950
Oil on canvas
34.9 × 26.7
Tate

51
Champ de Mars 1954–5
Oil on canvas
149.5 × 105
Museum Folkwang, Essen

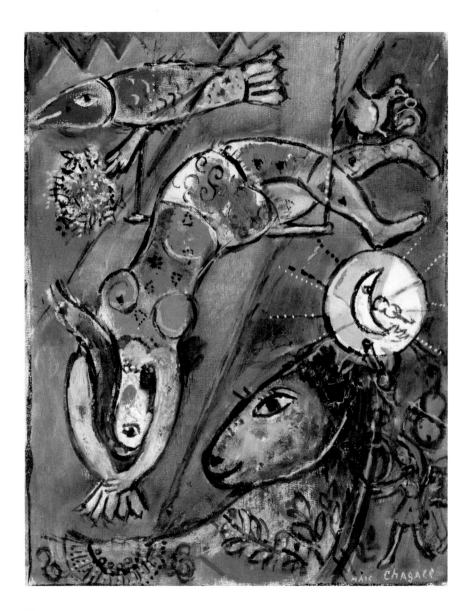

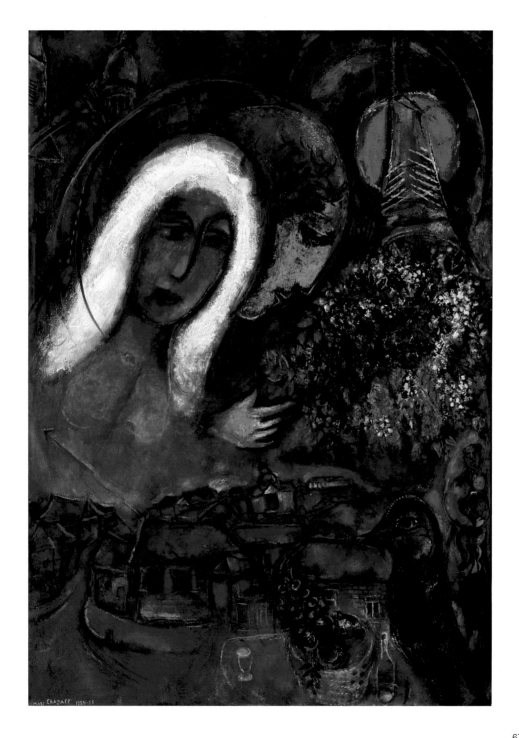

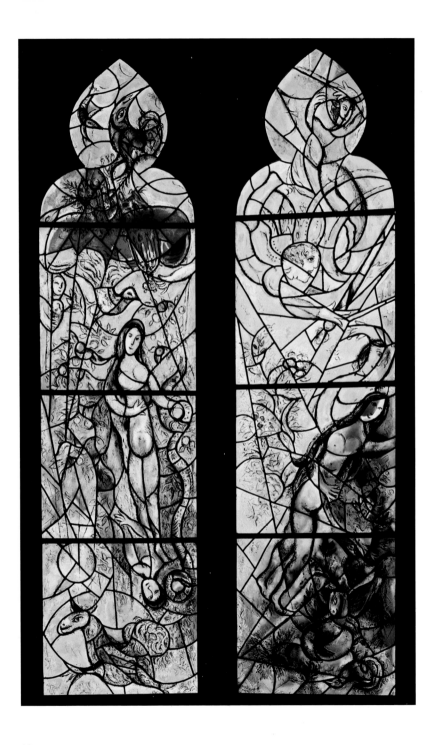

52
Adam and Eve, stained
glass windows, Cathedral
of St Etienne, Metz,
designed in collaboration
with Charles Marcq
and the Jacques Simon
Workshop, Reims, 1963–4

53
Ceiling of Paris Opéra,
1964

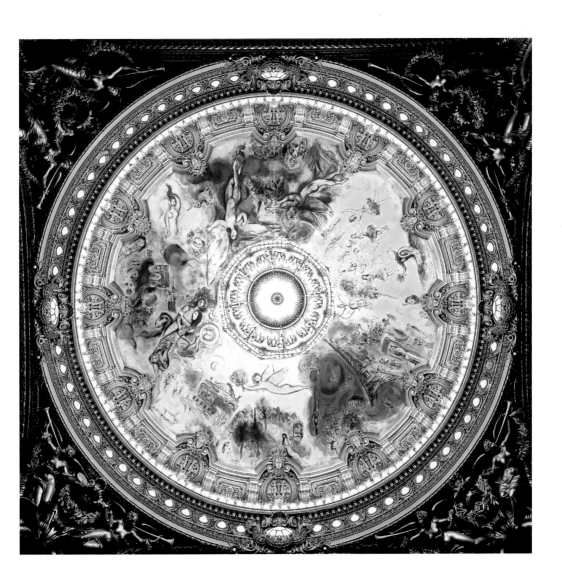

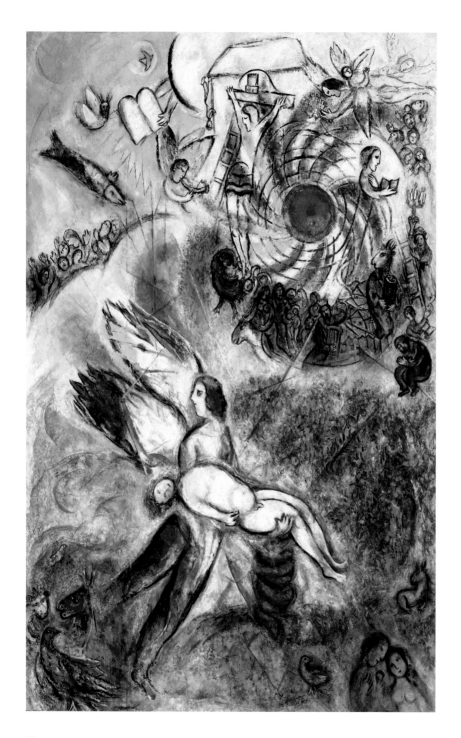

54
The Creation of Man
1956–8
Oil on canvas
300 × 200
Musée national Marc
Chagall, Nice

55
The Lovers and the Beast
1957
Moulded white clay
decorated with slip and
oxides
32.5 high
Private collection

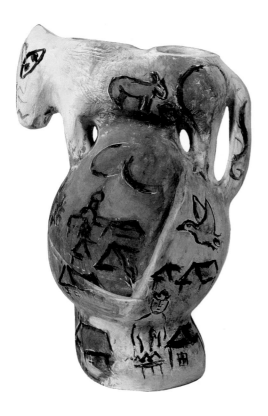
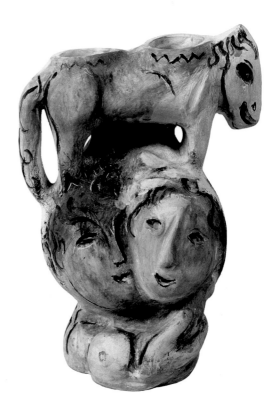

56
Life 1964
Oil on canvas
296 × 406
Fondation Marguerite et
Aimé Maeght, St Paul-de-
Vence

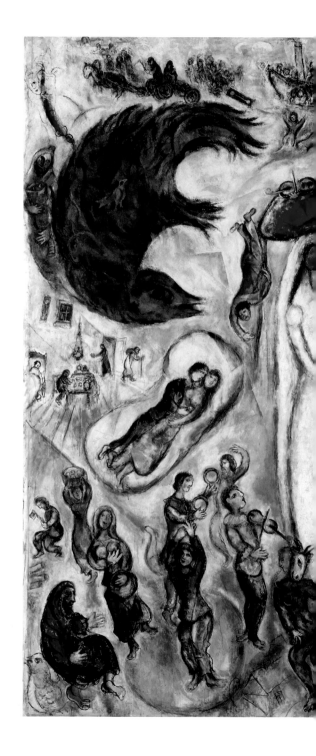

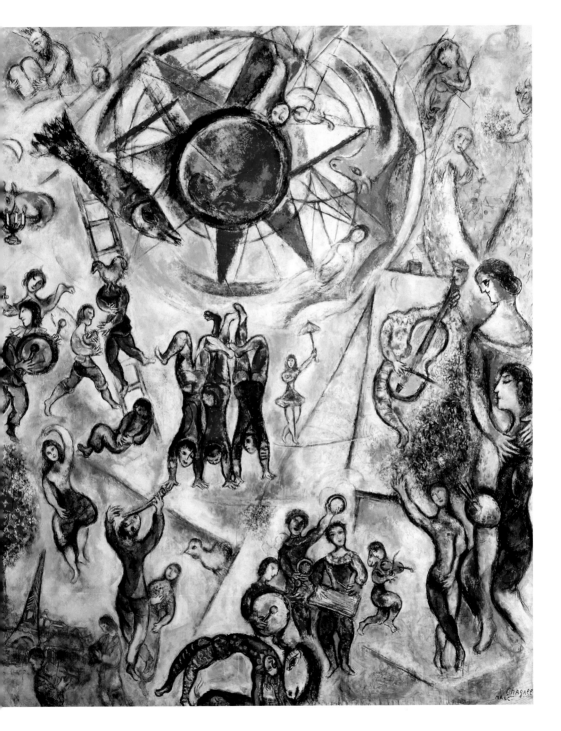

57
War 1964–6
Oil on canvas
163 × 231
Kunsthaus Zürich

58
The Fall of Icarus 1975
Oil on canvas
213 × 198
Musée national d'art
moderne, Centre Georges
Pompidou, Paris

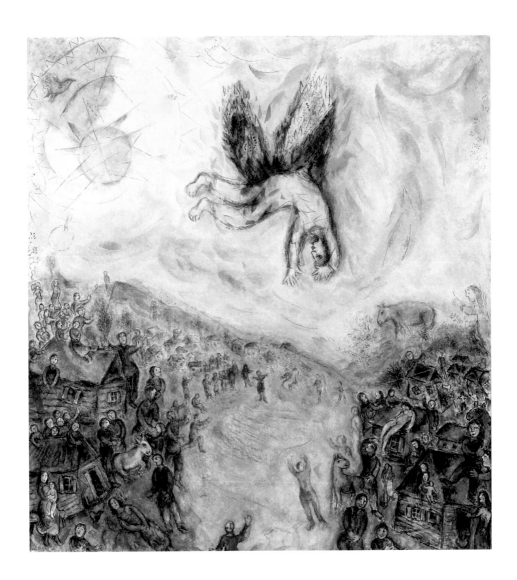

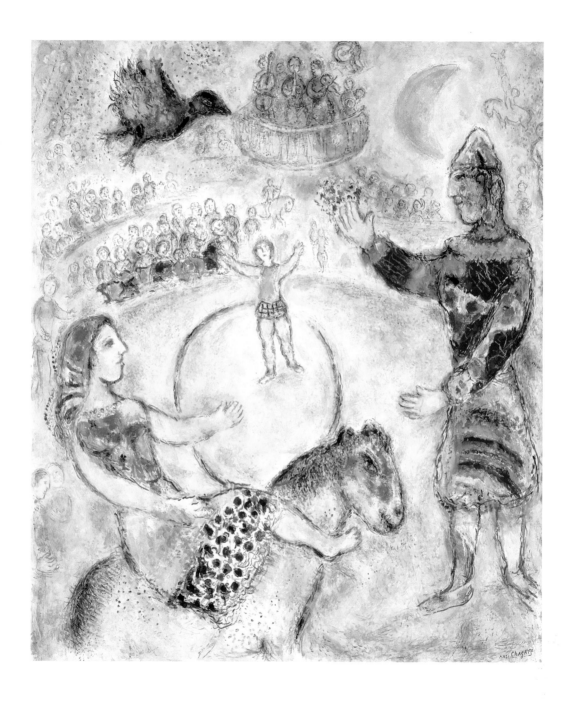

59
Large Grey Circus 1975
Oil on canvas
140 × 120
Private collection

60
The Studio in Green 1981
Gouache, pastel and
pencil on paper
42 × 63.7
Private collection, Paris

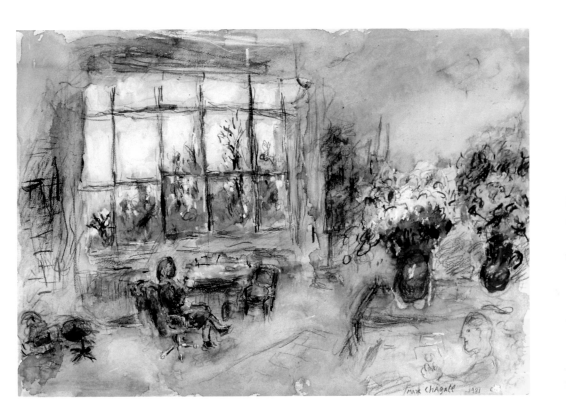

Notes

1. *My Life* was written in Russian in Moscow in 1921–2, but first published, in French, in 1931. It has since been translated into many languages. English publication details are as follows: Marc Chagall, *My Life*, Peter Owen Ltd, London 1957/1965; latest edition, Peter Owen Modern Classics 2010.

2. Marc Chagall, *My Life*, London 1965, p.56.

3. The taboo on graven images contained in the Second Commandment has in fact been far less consistently adhered to by the Jews than is commonly believed. The prohibition needs to be seen in its original biblical context, of Israel seeking to establish monotheism in a sea of idolatry. Later, when the context changed, the Jewish attitude to figurative art varied considerably from area to area and from period to period, for reasons as often political as religious. Prior to the nineteenth century, however, Jewish art tended to be the work of usually anonymous craftsmen (not all of them Jewish) intent on adorning places of worship or on producing ritual objects for use in the home or synagogue, to the greater glory of God.

4. Marc Chagall, *My Life*, London 1965, p.26.

5. Vitebsk had been a stronghold of Hasidic Judaism since the early eighteenth century. Originating in the extreme south-east of Poland-Lithuania in the 1730s under the leadership of the Baal Shem Tov, the movement – which had immense popular appeal – opposed the rationalism and intellectual pedantry of

Orthodox Judaism with an emphasis on ecstatic, intuitive communion with God.

6. Although domestic animals would have been part of his life even in the modest house on the outskirts of Vitebsk in which Chagall grew up, it is worth noting his frequent visits to his maternal grandfather who lived in the more rural (and almost exclusively Jewish) village – or *shtetl* – of Lyozno.

7. At first Chagall's ambitions were unfocused: 'I'll be a singer, a cantor ... a violinist ... a dancer ... a poet.' Marc Chagall, *My Life*, London 1965, p.41.

8. Mark (Mordechai) Antokolsky, a leading naturalistic sculptor of both Jewish and non-Jewish subjects, associated with the late nineteenth-century Wanderers group, was the first Jew to become well-known in the Russian art world. By identifying Jesus as a Jew, his *Ecce Homo* 1873 caused considerable controversy. It was probably in homage to him that Chagall changed his first name from Moyshe to Marc.

9. The Pale of Settlement, in which most Russian Jews were forced to live, was established in 1791 and remained in force until 1917. Residence in the capital required a special (and hard to obtain) permit, which often led to subterfuge and problems with the authorities.

10. *Mir Iskusstva* (World of Art), a society of Russian artists and writers founded in the 1890s, was in many respects the Russian counterpart of

the aesthetic and symbolist movements in the West.

11. Marc Chagall, *My Life*, London 1965, p.89.

12. Ibid., p.100.

13. Ibid., p.101.

14. Edouard Roditi, *Dialogues on Art*, San Francisco 1990, p.20; Marc Chagall, lecture given at Mount Holyoke College, USA, August 1943 and University of Chicago, March 1946 (published in Benjamin Harshav, *Marc Chagall on Art and Culture*, Palo Alto, CA 2003, p.68).

15. Marc Chagall, 'Blettlach', *Shtrom*, no.1, 1922, pp.44–6; for an English translation, see Ziva Amishai-Maisels, 'Chagall and the Jewish Revival: Center or Periphery?', in Ruth Apter-Gabriel (ed.), *Tradition and Revolution, The Jewish Renaissance in Russian Avant-Garde Art 1912–1928*, exh. cat., Israel Museum, Jerusalem 1987, pp.71–2.

16. Marc Chagall, *My Life*, London 1965, p.137.

17. Ibid., p.140.

18. Vollard's death in 1939, and the intervention of war, meant that these etchings were not published until 1956, by Greek-born editor and publisher Tériade.

19. The crucial role played by American journalist Varian Fry in saving several hundred eminent artists, writers and intellectuals from the clutches of the Nazis is still not sufficiently recognised.

First published 2013 by order of the Tate Trustees
by Tate Publishing, a division of Tate Enterprises
Ltd, Millbank, London SW1P 4RG
www.tate.org.uk/publishing

A catalogue record for this book is available from
the British Library

ISBN 978 1 84976 037 9

Distributed in the United States and Canada by
ABRAMS, New York

Library of Congress Control Number: 2013933765

Designed by Anne Odling-Smee, O-SB Design
Colour reproduction by DL Imaging Ltd, London
Printed and bound in Hong Kong by Printing
Express Ltd

Cover: Marc Chagall, *The Blue Circus* 1950, Tate.
Presented by the artist 1953 (detail of fig.50)
Frontispiece: Marc Chagall, *Self-Portrait with
Seven Fingers* 1912–13, oil on canvas, 126 x 107,
Collection Stedelijk Museum Amsterdam

Measurements of artworks are given in
centimetres, height before width and depth.

MIX
Paper from
responsible sources
FSC® C012285
www.fsc.org

Photo credits

References are to figure numbers

© Archives Marc et Ida Chagall,
Paris 2, 5, 13
© Photo Les Arts Décoratifs, Paris /
Jean Tholance 4
Art Institute of Chicago 9, 45
Bridgeman Art Library 42, 52, 60
Comité Marc Chagall, Paris 26, 29,
33, 38, 55, 59
Photo © Jean-Pierre Delagarde 53
© Museum Folkwang, Essen 51
Fondation Marguerite et Aimé
Maeght, St Paul-de-Vence 56
Getty Images / Roger Viollet 10
Getty Images / 2010 Gamma-
Features 12
Solomon R. Guggenheim
Museum, New York, Solomon
R. Guggenheim Founding
Collection, by gift 23
Photo © The Israel Museum,
Jerusalem, by Elie Posner 7
Photo © The Israel Museum,
Jerusalem, by Avshalom
Avital 48
Kunsthaus Zürich 40, 41, 57
Kunstmuseum Basel. Acquisition
supported by Dr h.c.Richard
Doetsch-Benziger, 1948. Photo:
Martin P.Bühler 21
Kunstmuseum Basel, Collection im
Obersteg 30
Kunstsammlung Nordrhein-
Westfalen, Düsseldorf 31
© 2008 Digital image, The Museum
of Modern Art, New York / Scala,
Florence 19
© 2006 Digital image, The Museum
of Modern Art, New York / Scala,
Florence 24, 47
Musée national d'art moderne /
Centre de création industrielle,
Centre Pompidou, Paris. Dation,
1988 15, 18, 37, 49, 58
Musée national d'art moderne /
Centre de création industrielle,
Centre Pompidou, Paris. Gift of
the artist, 1953. © Photo CNAC/
MNAM Dist. RMN – Jean-
François Tomasian 20
Musée national d'art moderne /
Centre de création industrielle,
Centre Pompidou, Paris. Gift of
the artist, 1953 49

© Photo CNAC/MNAM Dist. RMN –
Jacques Faujour 15
© Photo RMN – Gérard Blot 18
© Photo RMN – Grand Palais
(Musée Marc Chagall) / Gérard
Blot 11, 46, 54
© Centre Pompidou, MNAM-CCI,
Dist. RMN / Philippe Migeat 17,
36, 49
© Centre Pompidou, MNAM-CCI,
Dist. RMN / Grand Palais 58
Musée national Marc Chagall, Nice.
Donation, 1966 45, 54
© The State Russian Museum, St
Petersburg 28, 34
© The State Russian Museum,
St Petersburg, The private art
collection 27
© Tel Aviv Museum of Art 1, 44
© State Tretyakov Gallery,
Moscow 6, 8, 14, 35, 37, 39
© VG Bild-Kunst, Bonn
Kunstsammlung Nordrhein
Westfalen, Düsseldorf / Foto:
Walter Klein, Düsseldorf 16
Collection Stedelijk Museum,
Amsterdam p.2, 22, 25
Tate. Purchased 1942 32
Tate Photography 32, 50
© 2013 Museo Thyssen-Bornemisza
/ Scala, Florence 43
© Vitebsk Regional Museum,
Vitebsk 3

Copyright credits

Marc Chagall © ADAGP, Paris and
DACS, London 2013